AN ARTIST'S COLORING
TUTANKHAMEN

DOMINIQUE NAVARRO

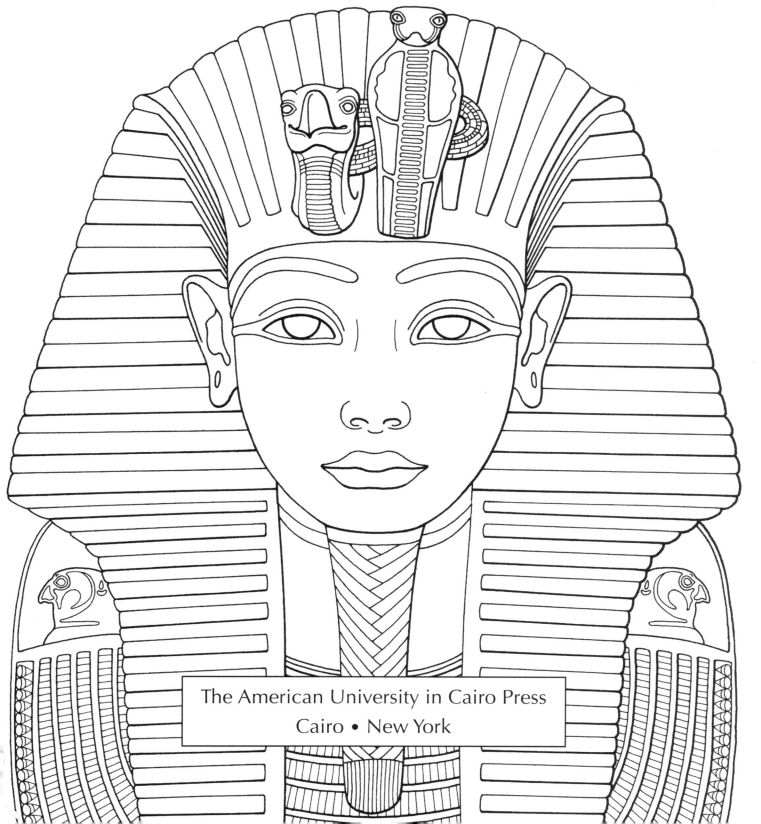

The American University in Cairo Press
Cairo • New York

PHARAOH TUTANKHAMUN

The legendary boy king Tutankhamun ruled Egypt during the 18th dynasty of the New Kingdom. About nine years old when he ascended the throne around 1332 BC, he died near the age of twenty. Believed to be the son of the controversial Akhenaten, and descendant of the great king Amenhotep III, Tutankhamun's short reign is filled with mystery and speculation, decadence and a divine legacy.

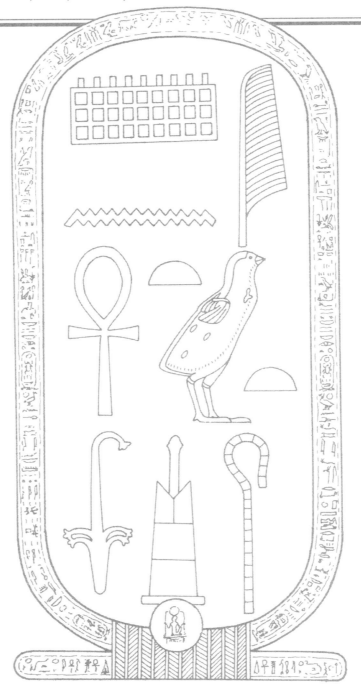

Tutankhamun's Birth Name

Tutankhamun's Throne Name Nebkheperure

ABOVE: A cartouche-shaped lid of a wooden box with the king's birth name in hieroglyphs. Kings could have as many as five different names, including a throne name. Royal names were written within the oval "cartouche," representing a length of rope tied in a loop.

RIGHT: Artwork from Tutankhamun's golden throne—one of his most magnificent possessions—depicting the king and his queen under the rays of Aten. Covered with sheet gold, it is adorned with silver, colored glass, and semi-precious stones like red carnelian and blue lapis lazuli.

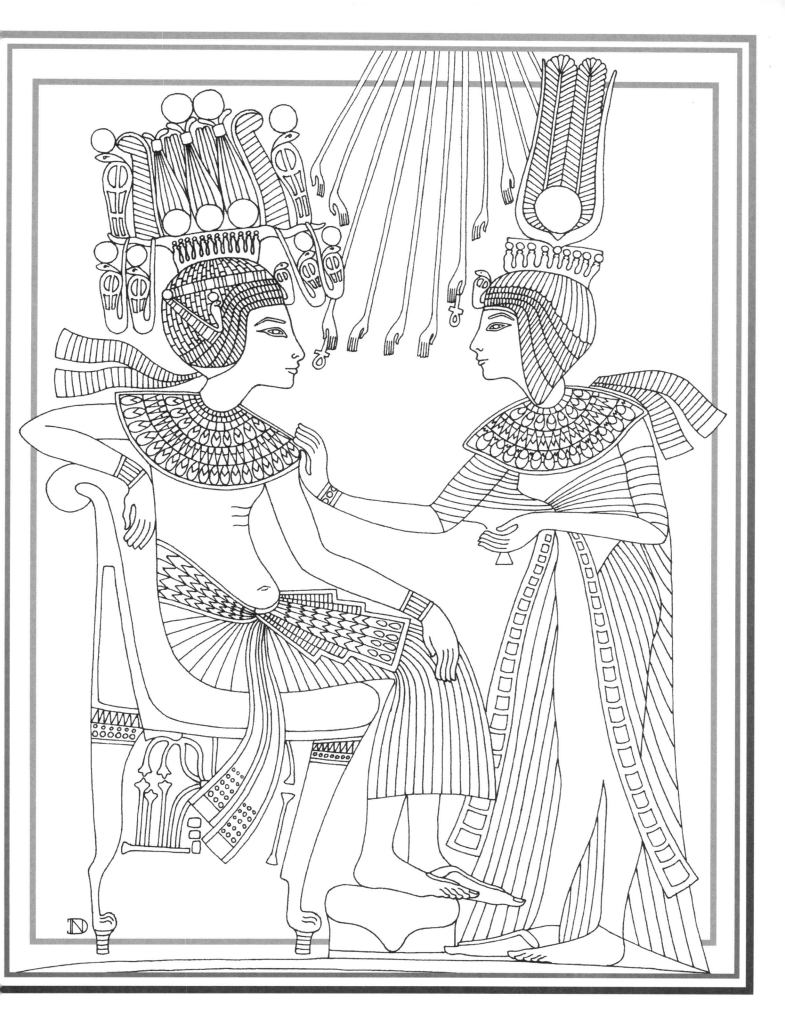

HOWARD CARTER

An artist and Egyptologist, Howard Carter (1874–1939) was born in England
and began working at his first excavation in Egypt when he was just seventeen.
After serving as Chief Inspector of the Egyptian Antiquities Service in Luxor,
Carter was hired by Lord Carnarvon in 1907 to excavate in the Theban Necropolis.
Despite setbacks and discouragement after years of searching, Carter finally
made the extraordinary discovery of Tutankhamun's nearly intact tomb in 1922.
The astonishing findings sparked worldwide fascination, and
Carter's name became synonymous with the legend of the young pharaoh.

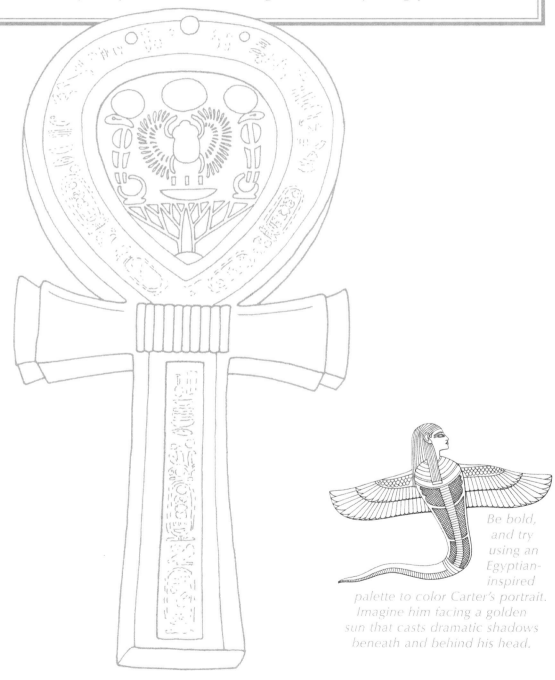

*Be bold,
and try
using an
Egyptian-
inspired
palette to color Carter's portrait.
Imagine him facing a golden
sun that casts dramatic shadows
beneath and behind his head.*

ABOVE: Golden mirror case in the form of an ankh, symbol
for "life," with inlaid blue glass and red carnelian stones.

RIGHT: Portrait of Howard Carter, from a famous painting
by his older brother, William, from 1924.

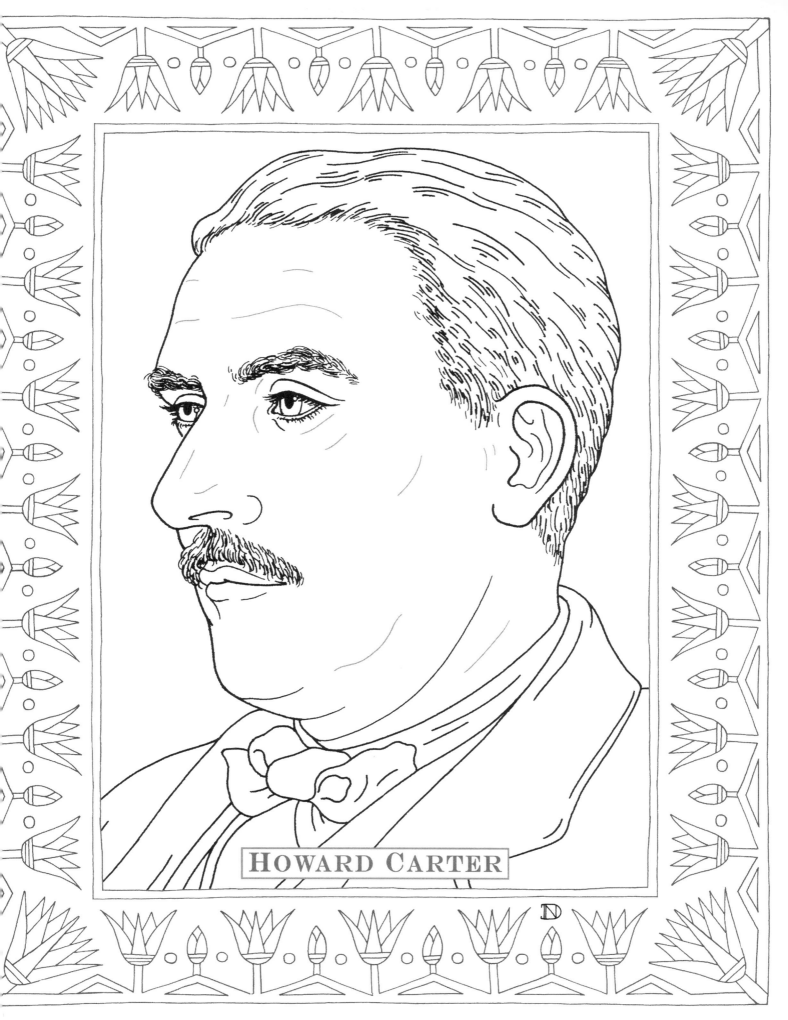

HOWARD CARTER

A TOMB OF TREASURES

Tutankhamun's tomb (KV62) was unfinished and is small compared to other royal tombs in the Valley of the Kings, but it was densely packed with objects. The burial chamber was painted a vibrant yellow and decorated with scenes of the king in different depictions: a royal funeral procession and mourners, his appearance in the underworld, arrival in the afterlife, and Tutankhamun's encounters with various deities including Osiris, Nut, Isis, Hathor, and Anubis.

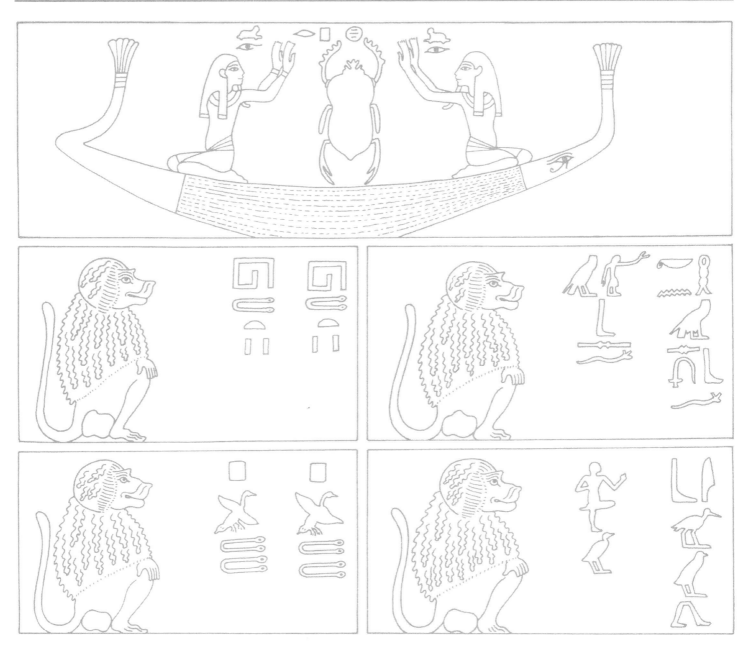

ABOVE: Artwork from the west wall of Tutankhamun's tomb, which depicts magical text for a safe journey through the underworld. The solar barque with the Khepri scarab is depicted with two forms of Osiris, along with twelve baboons corresponding to the twelve hours of the night.

RIGHT: Scene from the north wall of the tomb, in which Tutankhamun arrives in the afterlife dressed in the costume of the living, holding a staff, club, and ankh. He is welcomed by the goddess Nut who holds in both hands the sign for water, signifying "welcome."

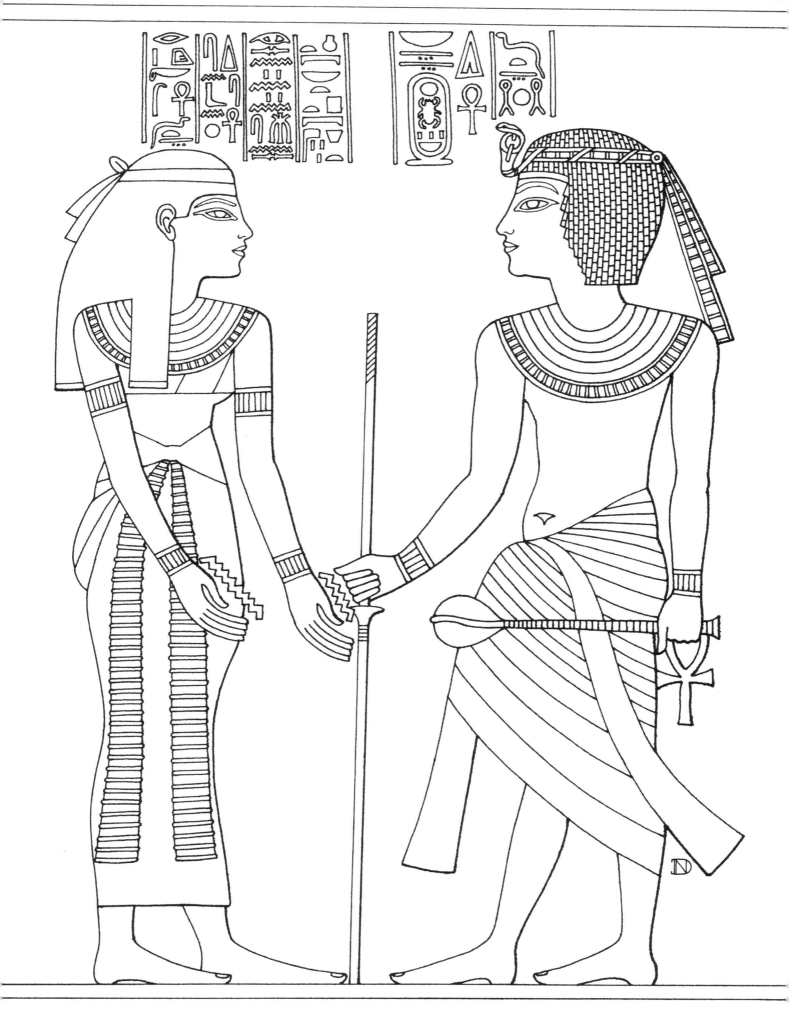

TUTANKHAMUN'S POSSESSIONS

Along with Tutankhamun's mummy inside a magnificent sarcophagus,
Carter found 5,398 items inside the tomb including lavish furnishings,
embellished shrines, golden jewelry, and magical amulets.
Each artifact reveals clues about the world of the king, allowing a glimpse
into his daily life: his family and marriage, leisure and war escapades,
religion and rituals, and extravagant preparations for the afterlife.
Piece by piece, we learn about the young man and his reign in ancient Egypt.

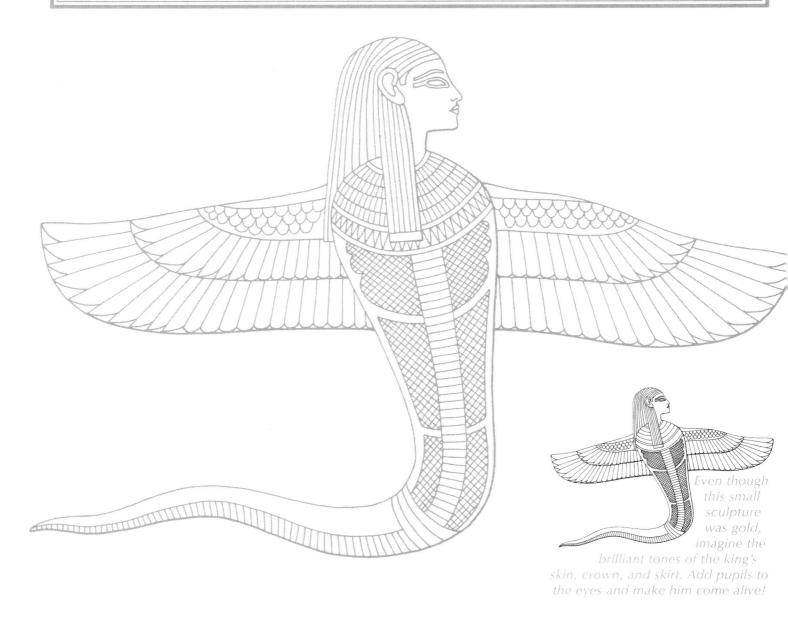

Even though this small sculpture was gold, imagine the brilliant tones of the king's skin, crown, and skirt. Add pupils to the eyes and make him come alive!

ABOVE: A magical gold amulet of a human-headed uraeus with wings, placed over the neck of the king's mummy. Amulets were included in the layers of mummy bandages as protection, and nearly 150 amulets, jewelry, and other objects were found within Tutankhamun's wrappings.

RIGHT: Among Tutankhamun's possessions was a tiny solid gold seated figure with a colorful beaded necklace. It was found within a gilded miniature coffin which bore the name of Queen Tiye—possibly Tutankhamun's grandmother—and enclosing a lock of her auburn hair.

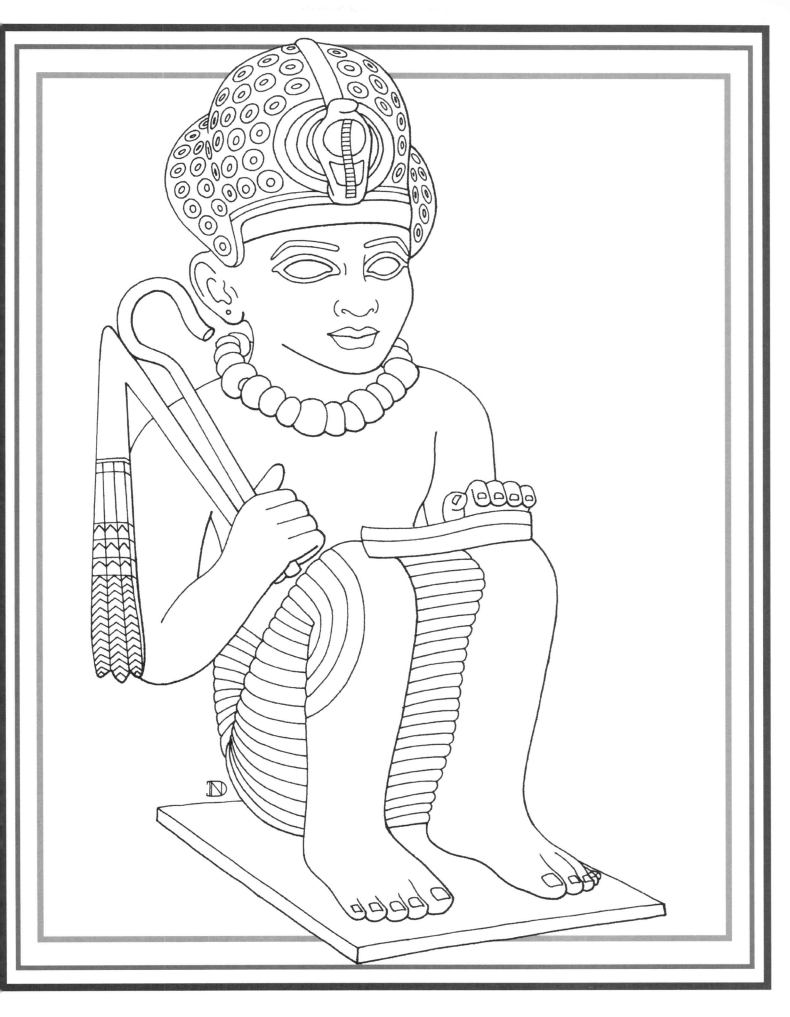

THE KING'S PROVIDENCE

As a child, Tutankhaten lived in the city of Amarna where his heretic predecessor Akhenaten disposed of tradition and cultivated revolutionary art and a new religion under the sun god Aten. Once young Tutankhaten became king, however, he returned the royal court to Memphis and Thebes, reinstated the worship of Amun, and altered his name to Tutankhamun. Although Egypt was restored to its old religious customs, the influence of Amarna art continued through Tutankhamun's reign, depicting a more naturalistic, animated, and intimate style, with exaggerated portraiture such as elongated features, slender limbs, a relaxed paunch, and soft skin folds.

Draw a wig or headdress on Tutankhamun, and a pair of embellished earrings!

ABOVE: Tutankhamun's alabaster "wishing cup" in the form of an open white lotus and buds, with kneeling figures of Heh, god of eternity, holding palm ribs with ankhs, atop tadpoles.

RIGHT: Head of young Tutankhamun as Nefertum (without paint chips and cracks). He emerges from a blue lotus flower, symbolic of the birth of the sun from the primordial waters.

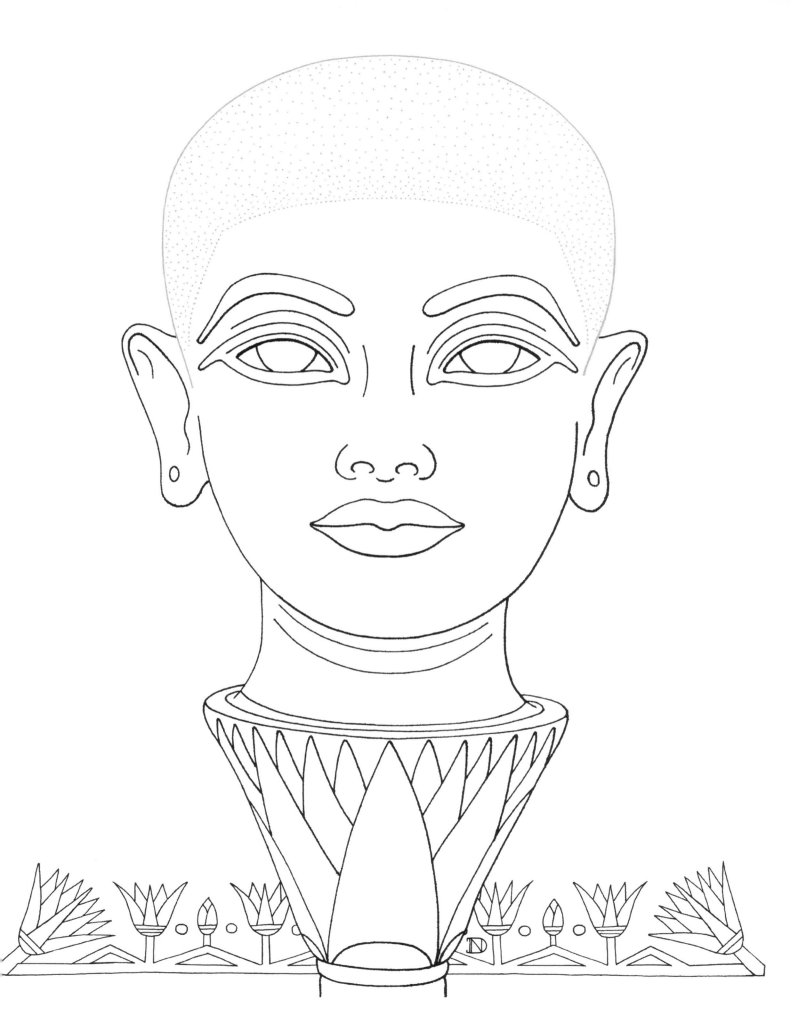

A WILD LIFE

Tutankhamun was surrounded by an extraordinary and often perilous environment over 3,000 years ago in Egypt: crocodiles and hippopotamuses inhabited the Nile River, lions and baboons were revered as gods, and raptors filled the sky. Pharaohs were often depicted beside their exotic pets, hunting wild game, enjoying lavish feasts of water fowl, and wearing regalia such as a leopard skin. The ancient Egyptians thrived in and were inspired by their natural environment, and it appears throughout their religion and art.

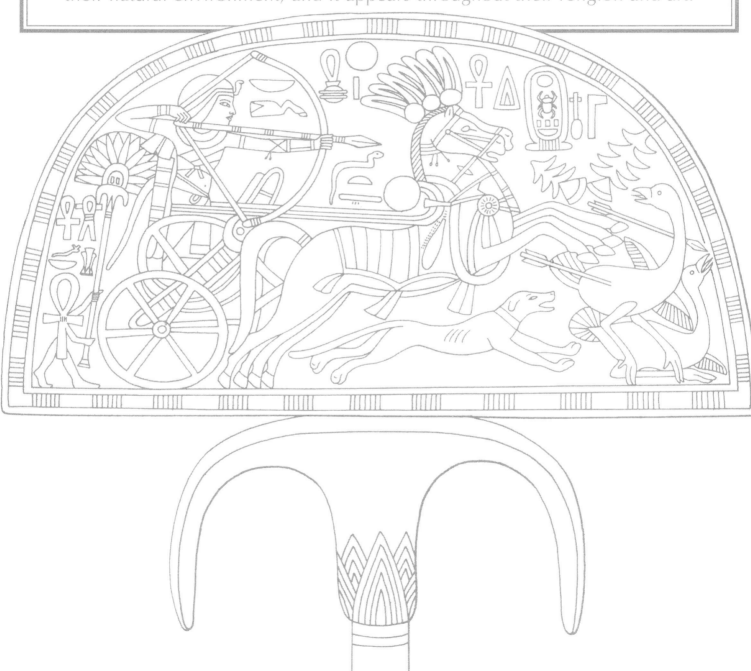

ABOVE: Tutankhamun's fan, which once held thirty lavish ostrich plumes. He is depicted hunting ostrich in the desert, accompanied by his pet dog. Behind his chariot, a walking ankh carries a similar golden fan complete with feathers.

RIGHT: Wooden golden statuette of Tutankhamun wearing the crown of Upper Egypt and riding a black panther, believed to refer to the passage of the king through the darkness of the underworld.

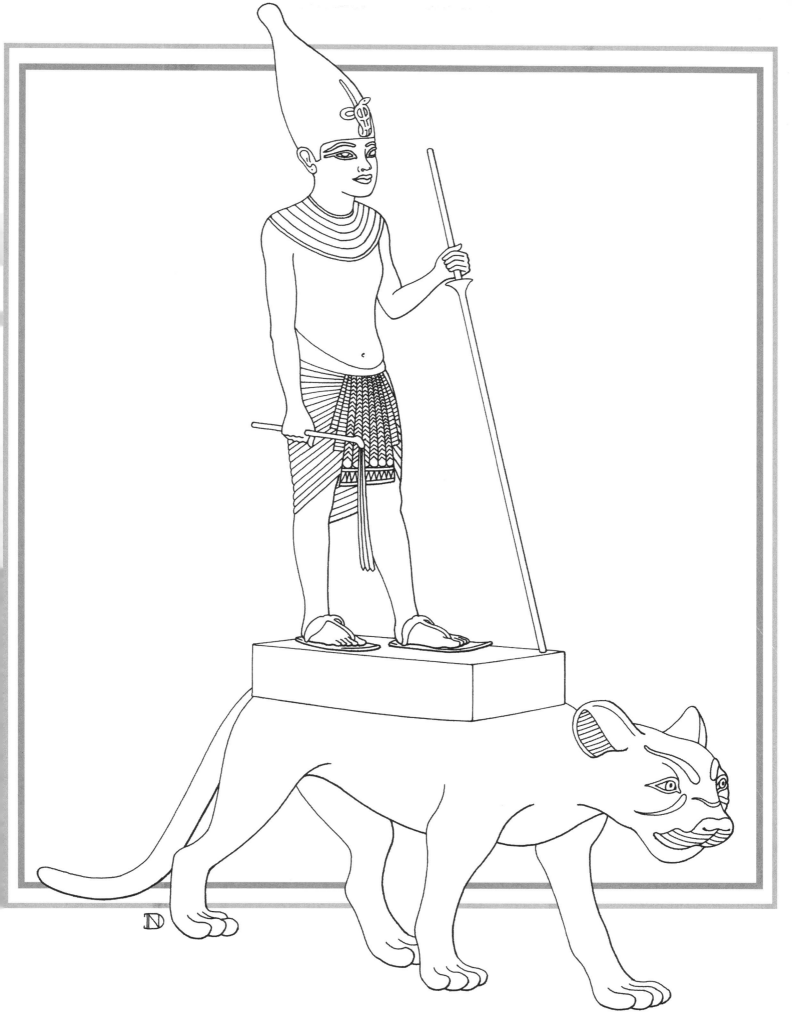

ROYAL MARRIAGE

Tutankhamun was married to Ankhsenamun, a daughter of Akhenaten and Nefertiti, thus ensuring his legitimacy as king. Sumptuous depictions of the royal couple adorn a golden shrine and other objects found in his tomb. The king and queen are shown in a variety of tender and intimate scenes— holding hands, sharing flowers, hunting fowl in the marshes together— tranquil in their loving companionship.

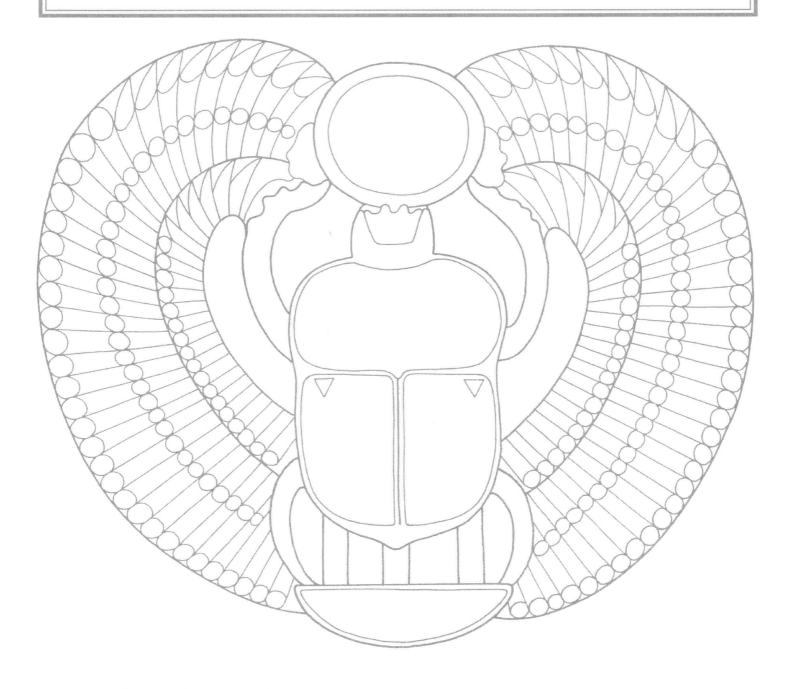

ABOVE: Scarab pectoral (worn on the chest) forming a rebus of Tutankhamun's throne name: the lapis lazuli scarab embraces a carnelian sun disk, with three strokes and a basket of turquoise. It symbolizes rebirth and resurrection.

RIGHT AND OVERLEAF: Scenes of Tutankhamun with his wife Ankhsenamun from the golden shrine. In a fascinating tradition of marsh scenes, the king and queen are depicted hunting water fowl among papyrus, his pet lion beside him.

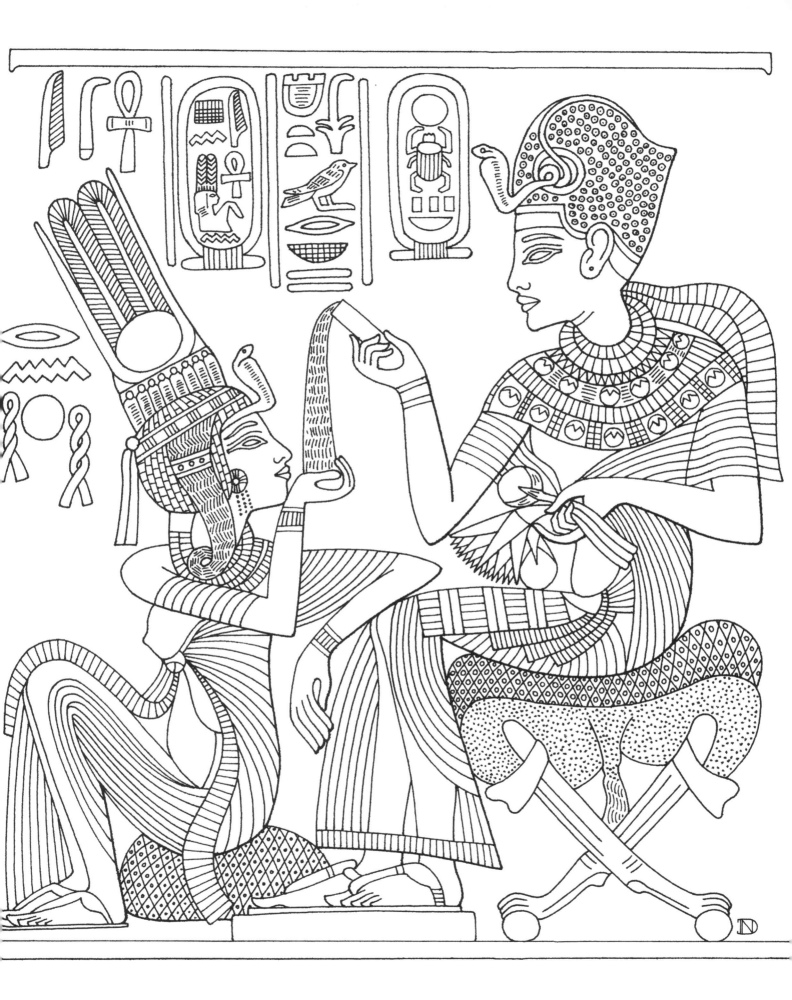

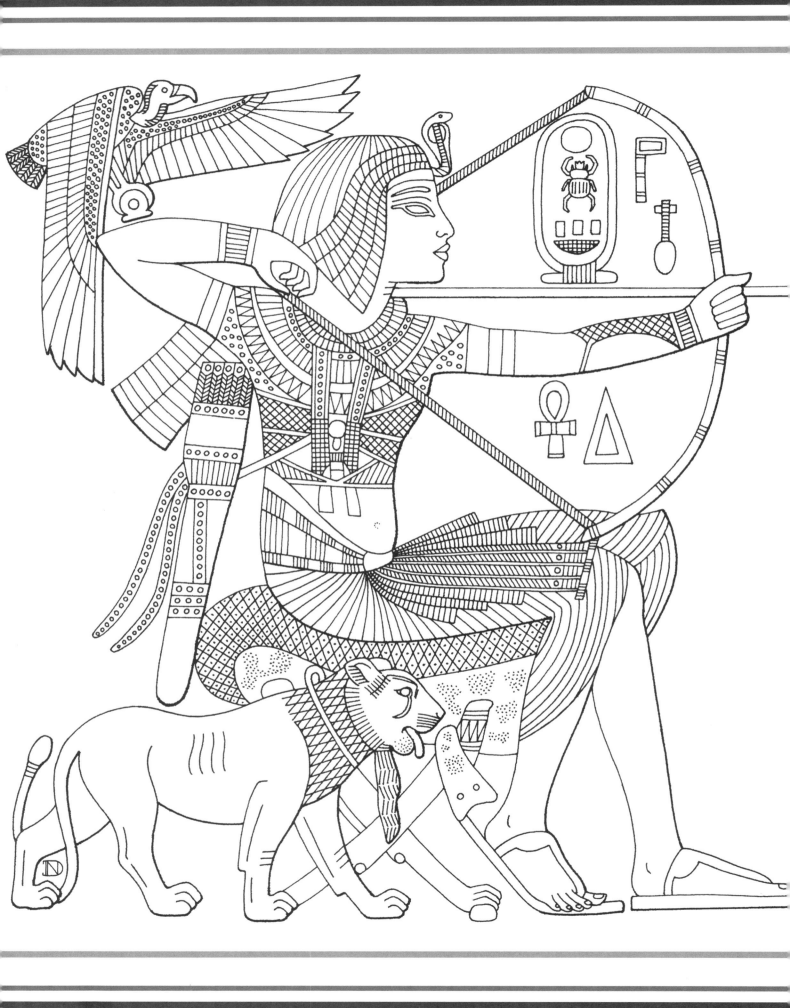

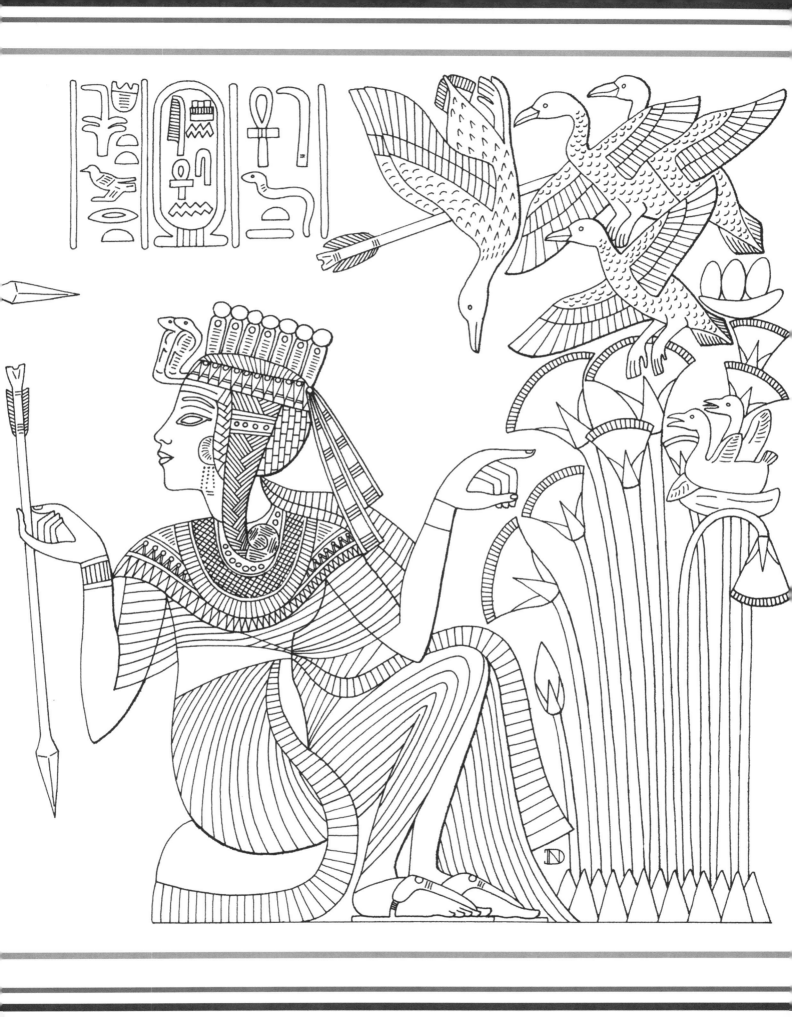

A VICTORIOUS LEGACY

Despite his youth and questionable vigor, Tutankhamun's reign was one of the greatest periods of restoration for Egypt, recovering from the social, political, and religious turmoil that Akhenaten's rule had caused. Tutankhamun reestablished diplomatic relations with old allies in foreign kingdoms, and he may have led military campaigns against Egypt's enemies. His tomb contained body armor, weapons, shields, and chariots—although some may have been ceremonial— and there are numerous depictions of the king vanquishing the enemy.

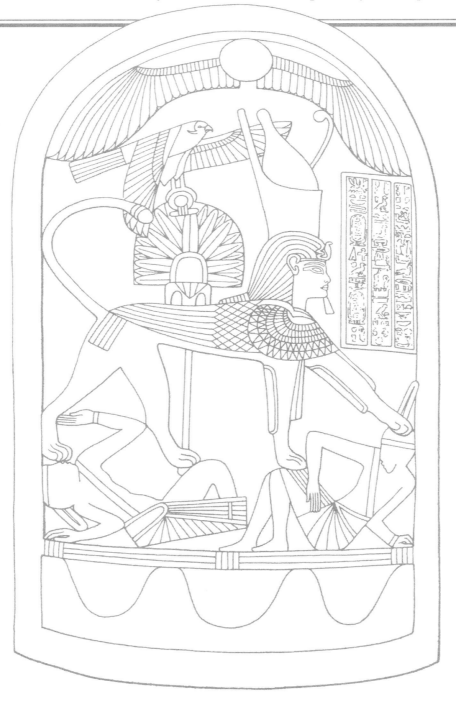

ABOVE: Ceremonial shield of the king as a powerful sphinx remorselessly trampling Egypt's enemies.

RIGHT: A scene from Tutankhamun's lavishly decorated "hunting box" depicting a conquering and formidable king.

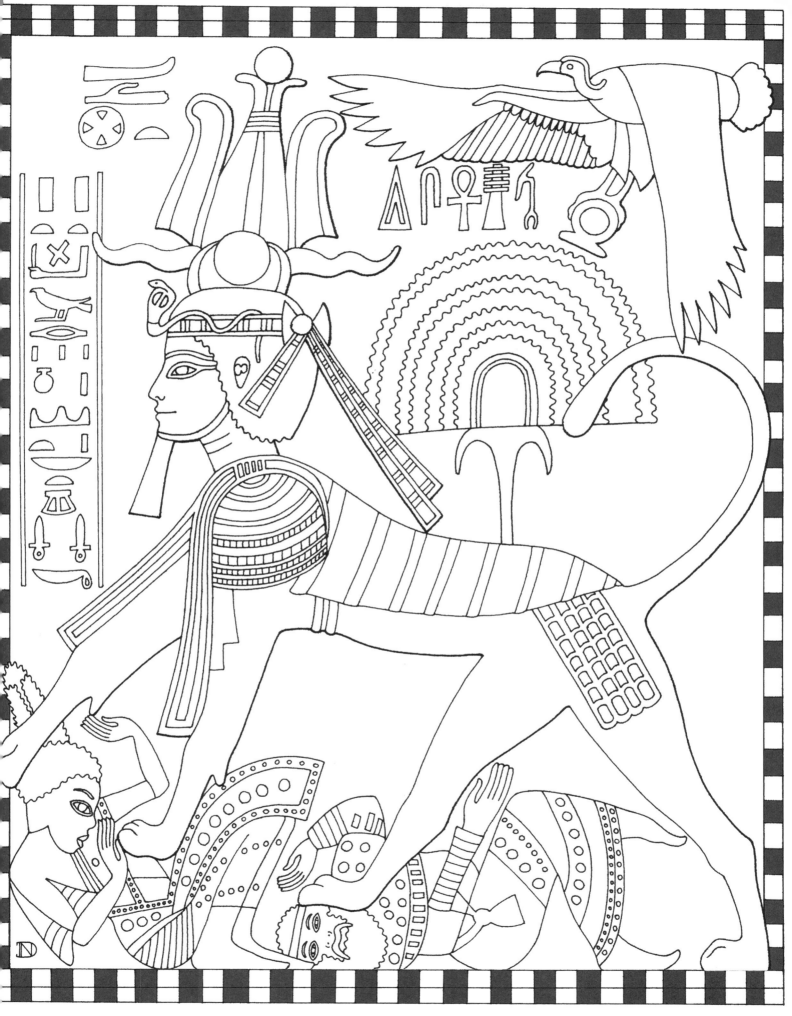

DIVINE POWER

Images of Tutankhamun as a warrior and hunter reinforced the ideology about the king's bravery and strength. He was victorious over the chaos that threatened Egypt in foreign lands, on the battleground, and in the treacherous desert, against fierce foes and wild beasts. Tutankhamun's power was likened to that of a god restoring and defending *ma'at*: order, balance, and harmony in the universe.

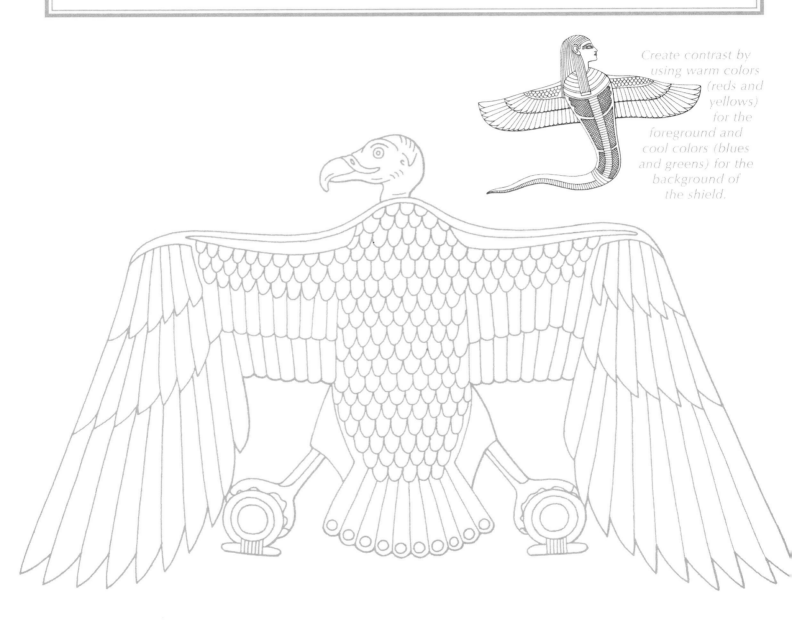

Create contrast by using warm colors (reds and yellows) for the foreground and cool colors (blues and greens) for the background of the shield.

ABOVE: Tutankhamun's necklace depicts the vulture goddess Nekhbet—divine protector of Egypt—holding the hieroglyphic sign for "infinity." It is made of solid gold, encrusted with red and blue glass. It was found around the king's neck within the bandaged layers of his mummy.

RIGHT: Gilded wooden shield depicting Tutankhamun slaying lions with a scimitar, symbolic of his role as defender and protector of Egypt. Eight shields were found in the tomb, four functioning, while the others were ceremonial, carved and gilded similar to this one.

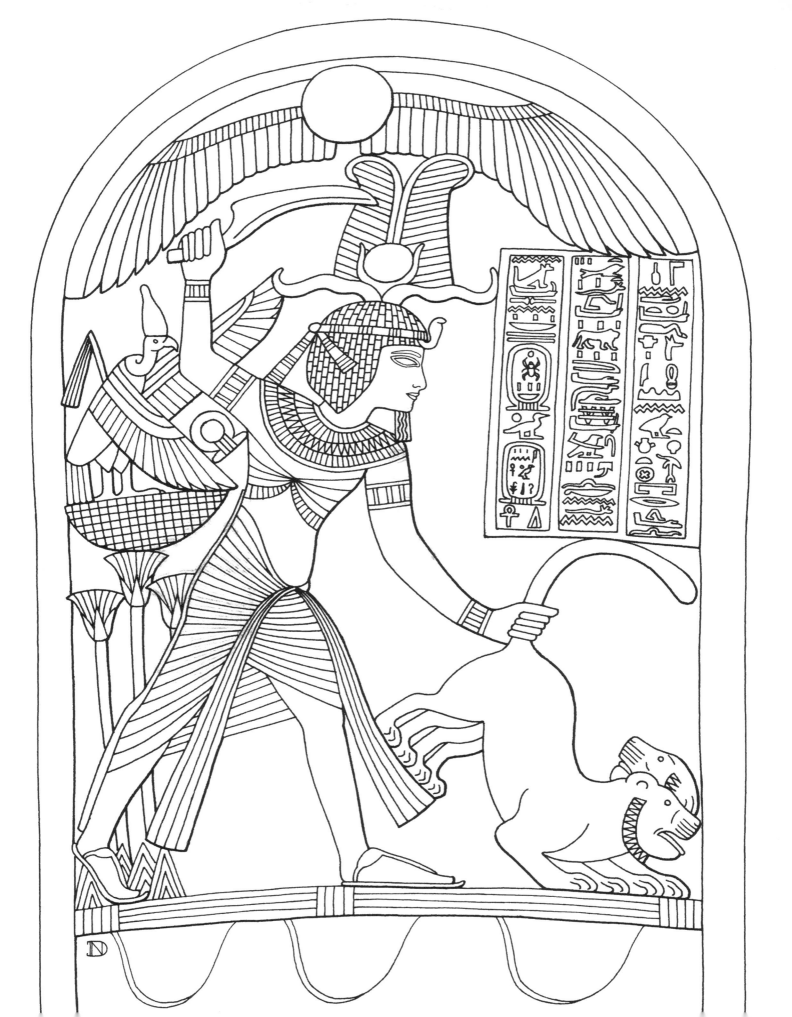

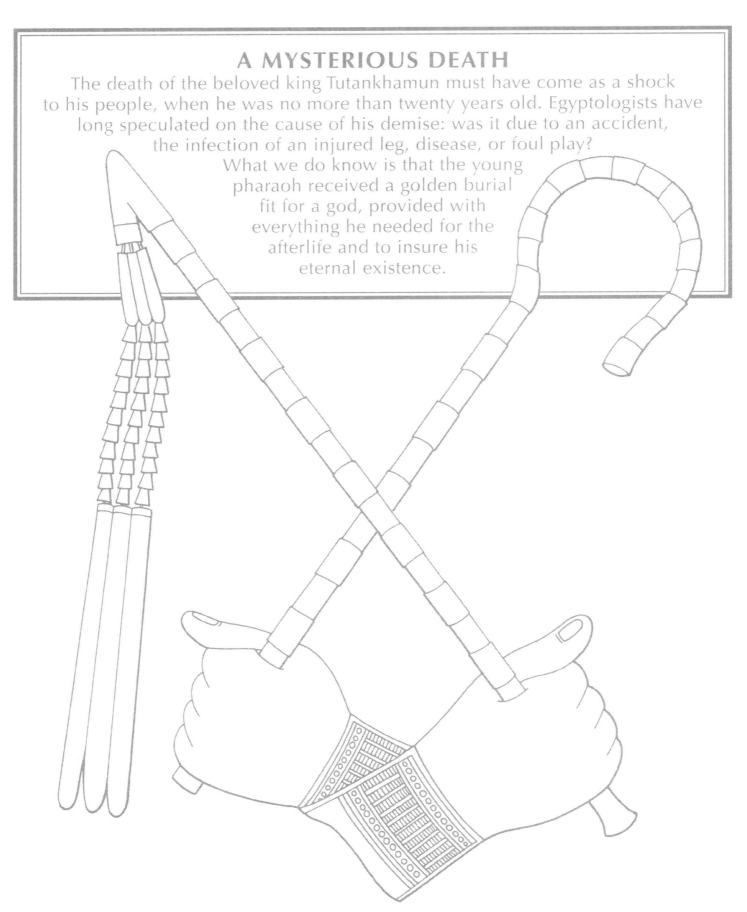

A MYSTERIOUS DEATH

The death of the beloved king Tutankhamun must have come as a shock to his people, when he was no more than twenty years old. Egyptologists have long speculated on the cause of his demise: was it due to an accident, the infection of an injured leg, disease, or foul play?
What we do know is that the young pharaoh received a golden burial fit for a god, provided with everything he needed for the afterlife and to insure his eternal existence.

ABOVE: Golden hands holding a crook and flail—emblems of the god Osiris and symbols of royalty—were placed on the torso of Tutankhamun's mummy.

RIGHT: The famed mask of Tutankhamun with the royal uraeus headdress (a cobra and vulture) was placed over the mummy. It is made of solid gold and semi-precious stones,

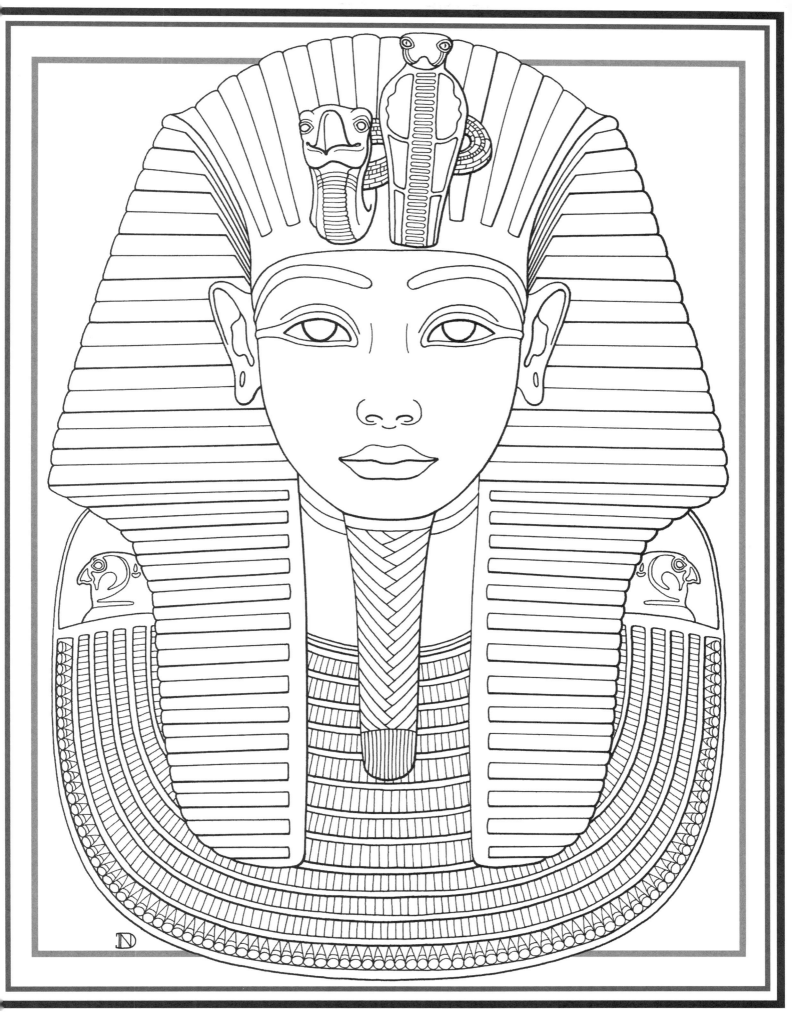

CANOPIC SHRINE

During the mummification process, embalmers prepared the pharaoh's body and removed his organs, placing them inside a canopic chest with four jars. Tutankhamun's elaborate funerary equipment included a golden shrine to hold the chest, with four goddesses standing guard: Isis, Nephthys, Neith, and Selket.

Imagine Selket standing in a golden ray of light, casting a dark shadow across the gilded shrine behind her.

ABOVE: Beautifully carved in alabaster and portraying the king, four stoppers sealed the jars inside the canopic chest. Inside were detailed miniature royal coffins holding the king's mummified internal organs.

RIGHT: With the scorpion upon her head, Selket was a goddess of magic, healing, and childbirth. She is one of the goddesses guarding the gilded golden shrine that housed Tutankhamun's canopic chest.

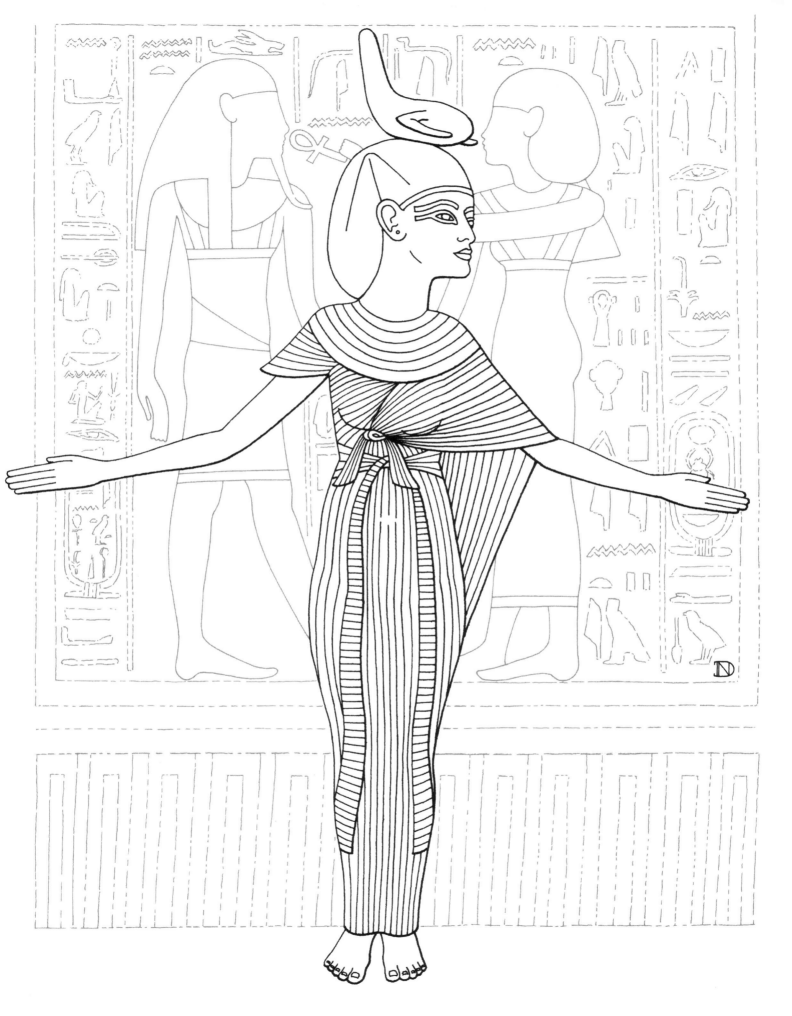

FUNERARY BEDS

Among Tutankhamun's many possessions found within the tomb were three enormous beds, each with a different divinity: a cow goddess, a lion goddess, and Ammut, a mythical creature. It is suspected they were used in religious rituals during the mummification and funeral of the king.

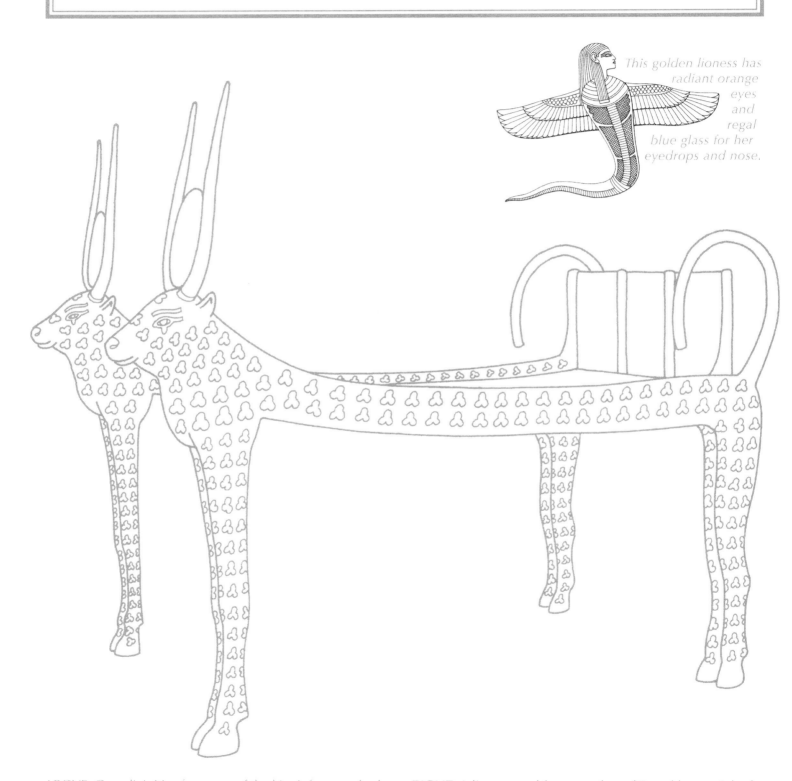

This golden lioness has radiant orange eyes and regal blue glass for her eyedrops and nose.

ABOVE: Cow divinities form one of the king's funerary beds. RIGHT: A lioness god from another of Tutankhamun's beds.

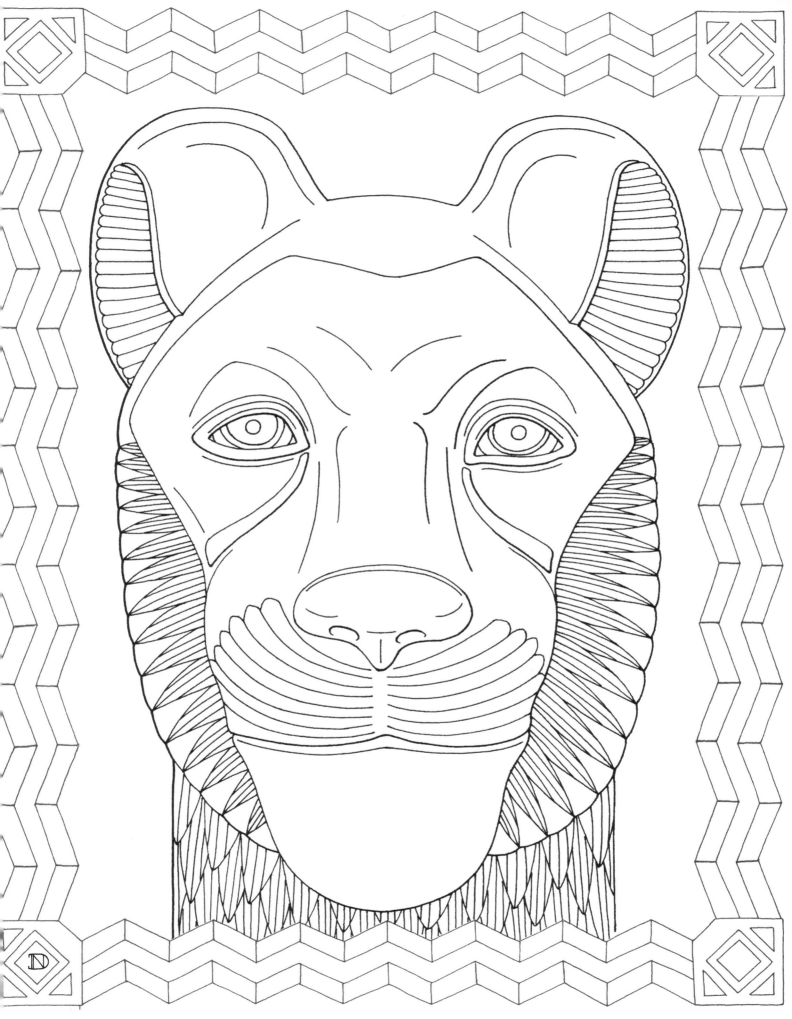

WONDERFUL THINGS

The extraordinary objects in Tutankhamun's tomb—"wonderful" as Carter
described it all—chronicle the remarkable life of the young pharaoh and
his eternal aspirations. Numerous pieces are functionally self-evident,
while others remain mysterious or simply mystical, such as a seed filled
"bed for Osiris," magic bricks and oars, and 413 shabti figures.
Invaluable unguents (ointments, oils, or perfumes) in ornately carved vessels
were stolen by grave robbers, even while they left gold and jewelry behind.
Among other necessities, Tutankhamun went to the afterlife with
35 model boats. Boats were the prevalent means of travel in ancient Egypt,
and were associated with the divine journeys of both kings and gods,
including the passage of the sun at night, and Tutankhamun
navigating the underworld to get to the afterlife.

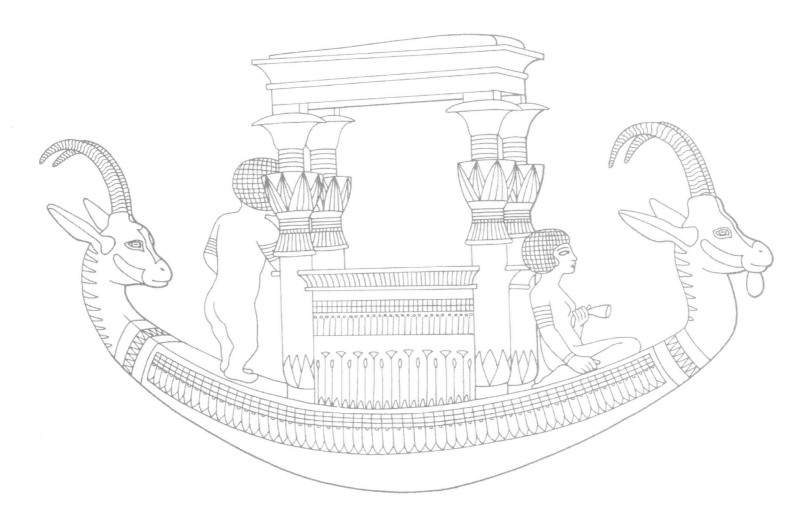

ABOVE: Intricately carved in alabaster, this ornamental boat
was fixed upon a hollow rectangular base which could carry
liquid so that the vessel would appear to float.

RIGHT: Alabaster ibex with real horns, one of which has gone
missing (shown here restored). Its body is hollowed to hold
unguent, which was stolen by grave robbers.

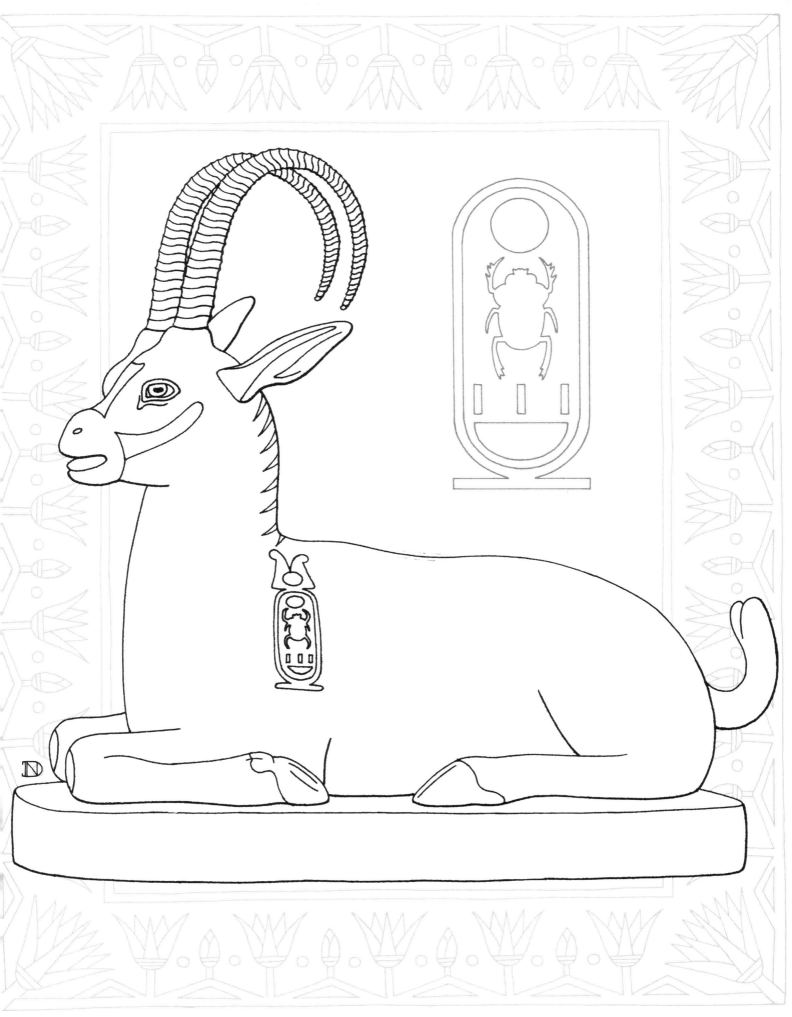

TUTANKHAMUN THE ETERNAL
Tutankhamun is an extraordinary figure in ancient Egypt's fascinating history.
His tomb, and all his possessions, intrigue our imagination about
his brief journey in the land of the living into the eternal afterlife,
protected by the jackal god Anubis. Today, the golden legacy of
the boy king lives on and continues to captivate the world.

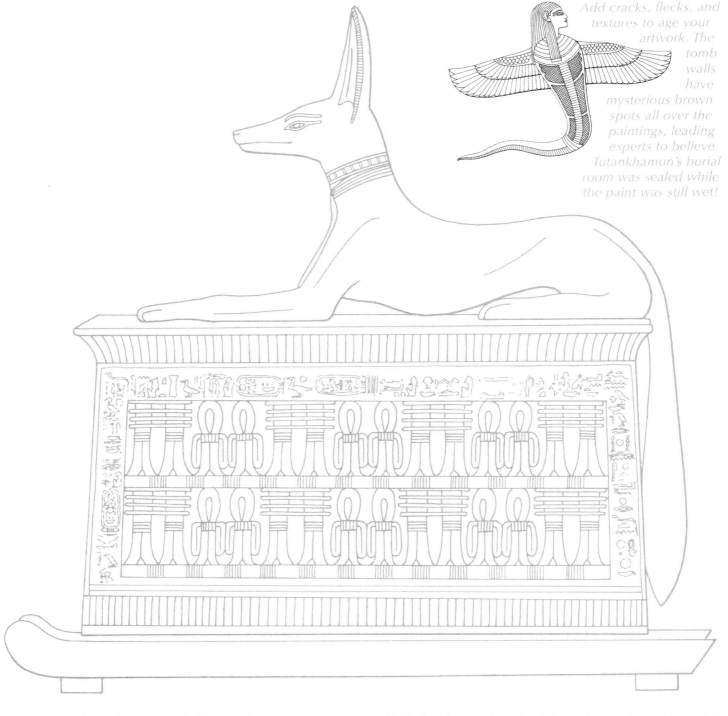

Add cracks, flecks, and textures to age your artwork. The tomb walls have mysterious brown spots all over the paintings, leading experts to believe Tutankhamun's burial room was sealed while the paint was still wet!

ABOVE: A golden shrine guarded by Anubis, god protector of the necropolis and underworld, with obsidian and silver.

RIGHT: On the south wall of Tutankhamun's tomb, Anubis places a protecting hand on the shoulder of the king.

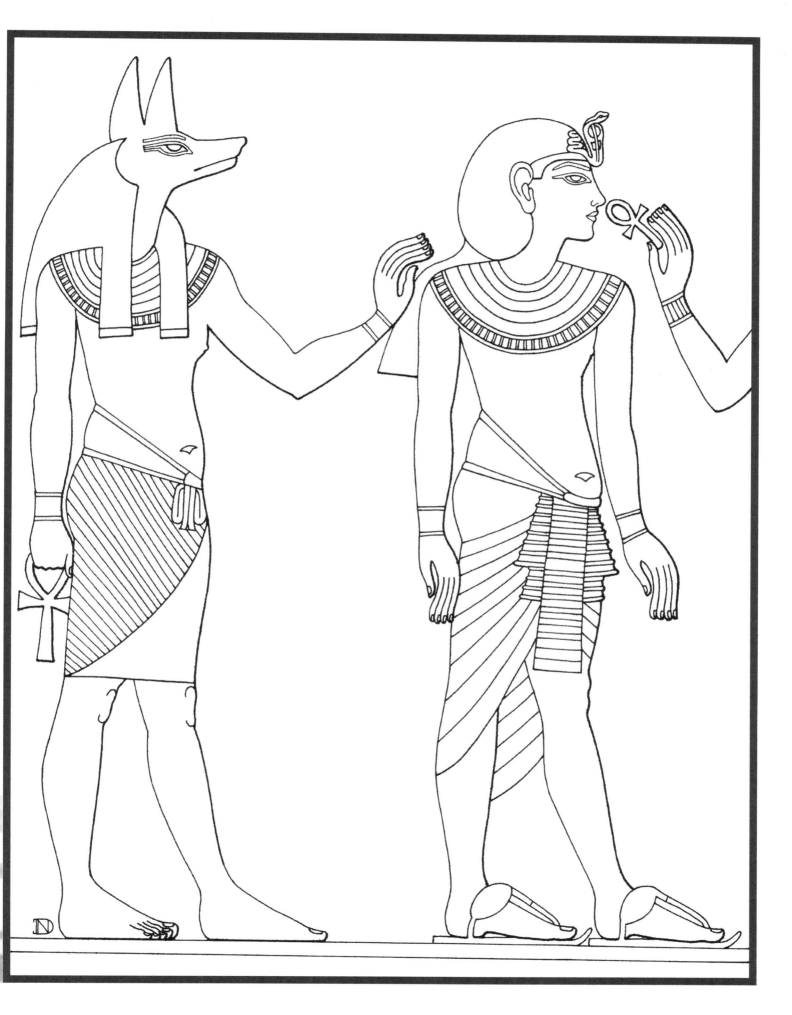

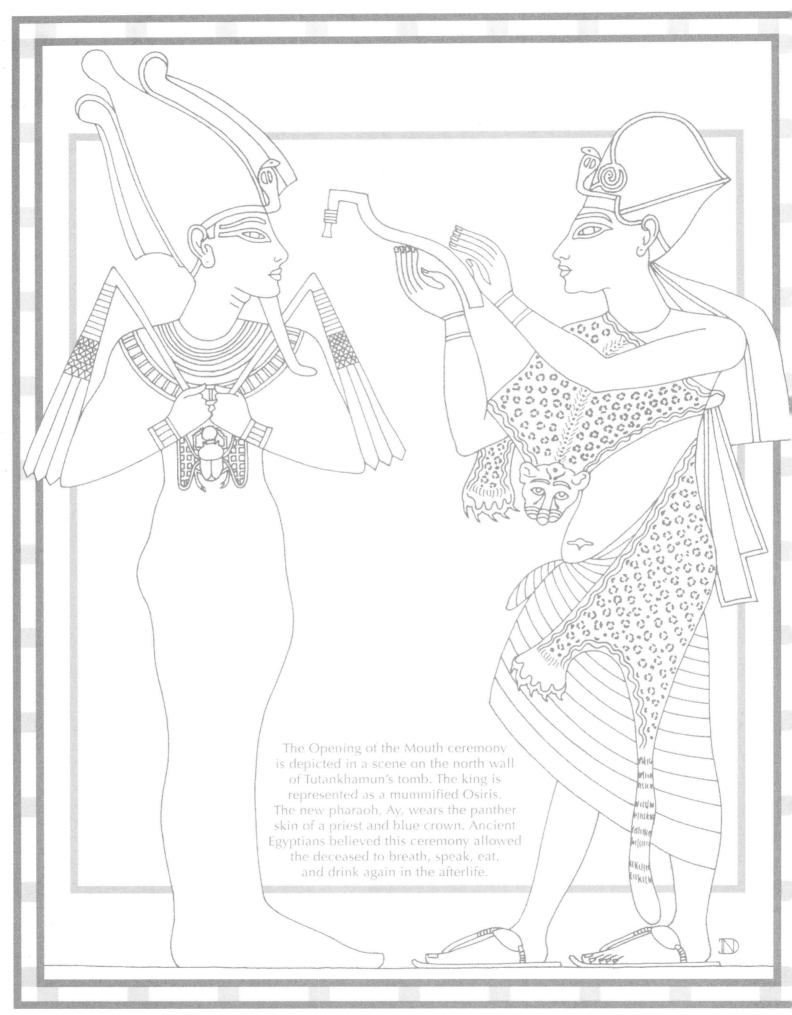

The Opening of the Mouth ceremony
is depicted in a scene on the north wall
of Tutankhamun's tomb. The king is
represented as a mummified Osiris.
The new pharaoh, Ay, wears the panther
skin of a priest and blue crown. Ancient
Egyptians believed this ceremony allowed
the deceased to breath, speak, eat,
and drink again in the afterlife.